C000060855

فضائل الشام

The Virtues of Shām
First Edition
Published by Ark of Knowledge Publications, Leeds
info@aokpubs.com
Copyright © 1445/2023, Abū Ubaydah Arsalān Yūnus

ISBN: 9798867493851

All rights reserved. No portion of this book may be
reproduced in any form without permission from the
publisher, except as permitted by U.S. copyright law.

Cover design and typesetting by ihsaandesign.com.

While every precaution has been taken in the
preparation of this book neither the authors,
translators, nor publishers shall have any liability with
respect to any loss or damages caused nor do the views
expressed in this book are necessarily held by the
publisher directly or indirectly by the instructions or
advice contained in this book.

THE VIRTUES
of SHĀM

A Translation of
Fadāʾil ash-Shām

by Imām Ibn ʿAbd al-Hādī (d. 744 AH)

Translated, Edited and Annotated by
Abū Ubaydah Arsalān Yūnus

Ark of Knowledge

PUBLICATIONS

Contents

Publisher's Note ..9

Historical Background ..13

The Breadth Of *Shām* .. 13

Syria, Suriya and Assyria ..13

Shāmin, Shām and *Aram* ..14

Ancient Civilisations ...14

Ibrahim (﷽) In *Shām*..15

Cananites To The Babylonian (Chaldean) Empire15

Shām In The Roman Empire15

Queen Zenobia (Zaynab) ...16

Christianity In *Shām* ...16

The Prophet ﷺ In *Shām* ...16

Conquest Of *Shām* ..16

Companions Buried In *Shām*17

Umayyad Dynasty ...17

Abbasid Dynasty ... 17

Fatimid, Seljuk And Zangi Dynasty18

Salāhudīn Ayūbī In *Shām*18

Mamlūk Dynasty ..18

Tatar Attacks And The Crusaders End In *Shām*18

Ottoman Dynasty ...18

Shām In The 20th Century19

Biography Of Imām Ibn ʿAbdil Ḥādī21

Name..21

Birth..21

Teachers ..21

Virtues..21

His Books..22

Death ..22

CHAPTER ONE: ĀYĀT AND AHADĪTH ABOUT THE VIRTUES OF SHĀM ..**23**

Ḥadīth 1 .. 26

Ḥadīth 2 .. 28

Ḥadīth 3 .. 30

Ḥadīth 4 .. 31

Ḥadīth 5 .. 32

Ḥadīth 6 .. 33

Ḥadīth 7 .. 34

Ḥadīth 8 .. 35

Ḥadīth 9 .. 36

Ḥadīth 10 .. 37

Ḥadīth 11... 39

Ḥadīth 12 .. 40

Ḥadīth 13 .. 41

Ḥadīth 14... 44

Ḥadīth 15 .. 45

Ḥadīth 16... 46

Ḥadīth 17... 47

Ḥadīth 18... 48

Ḥadīth 19... 50

Ḥadīth 20 .. 51

Ḥadīth 21... 52

CHAPTER TWO: WHAT HAS BEEN MENTIONED REGARDING THE FITAN ARISING FROM THE EAST

FITAN ARISING FROM THE EAST ...**53**

Ḥadīth 22 ...54

Ḥadīth 23 ...55

Ḥadīth 24 ...57

Ḥadīth 25 ...58

Ḥadīth 26 ...59

Ḥadīth 27 ...60

Ḥadīth 28 ...62

Ḥadīth 29 ...63

Ḥadīth 30 ...65

Ḥadīth 31..66

Ḥadīth 32..67

APPENDIX: ADDITIONAL AHADĪTH RELATED TO SHĀM

APPENDIX: ADDITIONAL AHADĪTH RELATED TO SHĀM**69**

Ḥadīth 1 ...70

Ḥadīth 2 ...71

Ḥadīth 3 ...72

Ḥadīth 4 ...73

Ḥadīth 5 ...74

Ḥadīth 6 ...75

Ḥadīth 7 ...76

Ḥadīth 8 ...77

Ḥadīth 9 ...78

Publisher's Note

I begin with every beautiful name that belongs to Allāh, the Most Gracious, the Most Merciful. All complete praise is due to Allāh alone the *Rabb*[1] of all that exists. May blessings and greetings be upon the best of His creation Muḥammad (ﷺ), the last and final Messenger, and upon his family, companions and all those who follow him until the day of Judgement.

This is a comprehensive translation of the book *Faḍāʾil Ash-Shām*, or *The Virtues of Shām*, by the great scholar Shaykh Imām Muḥammad b. Aḥmad b. ʾAbdil Hādī also famously known as Imām Ibn ʾAbdil Hādī. This is a short treatise that includes two main sections which discuss *Āyāt* and *Ahadīth* about the virtues of *Shām*, and *Ahadīth* which mention the rise of *Fitnah* from the East.

Allāh has given some people superiority over other people, as well as some days superiority over other days. Similarly, He has given superiority and bestowed virtue on some areas of the Earth over others such as Makkah, Madinah and *Shām* etc. Allāh the Most High says,

يَٰقَوۡمِ ٱدۡخُلُوا۟ ٱلۡأَرۡضَ ٱلۡمُقَدَّسَةَ ٱلَّتِي كَتَبَ ٱللَّهُ لَكُمۡ

[When Mūsā (ﷺ) said to his people] O my people, enter the blessed land [i.e., Palestine] which Allāh has assigned to you. [Sūrah Māʾidah, āyah no.21]

Imam Qatādah explains that the meaning of "the blessed land" is *Shām*.[2]

1. [TN] The word *Rabb* has a vast meaning. Its detailed meaning is the Sustainer, Cherisher, Master and Nourisher.

2. [TN] *Tafsīr at-Tabarī*, vol.4, p.45 and it's *Isnād is Hasan*.

The Prophet (ﷺ) said,

> Allāh, the Exalted and Glorious, took the covenant
> from me, just as He took the covenant from the
> Prophets (ﷺ). He gave the good news of me to Īsā
> b. Maryam (ﷺ) and my mother had a dream [at the
> time of my birth] in which she saw exiting from
> between her feet a torch which illuminated the
> palaces of *Shām*.[3]

Ibn Kathīr said, the fact that *Shām* is singled out in conjunction
with his light indicates that his (ﷺ) religion and teachings will
abide in the land of *Shām*. Various scholars have authored books
on the virtues of Shām. Two of the more famous ones are *Virtues of
Shām* by Imām Samʾāni and *Virtues of Shām and Damascus* by ʾAlī b.
Muḥammad ar-Rab'i.

In recent years, the people of *Shām* have been undergoing huge
tribulations in which they are being oppressed. Women are being
widowed, children are being slaughtered and weak old people are
being dragged to the ground. We believe that this is a temporary
test on the people of *Shām*, which will remove the corruption and
create more *Īmān* among them after which it will become the
stronghold (heartland) of the believers according to the prophecy
of the Prophet (ﷺ).

In order for the reader to humanise with the people of *Shām*
I have included some pre-reading sections which gives some
historical background of *Shām*. Additionally, I have included a brief
biography of Imām Ibn ʾAbdil Hādī and an appendix section which
includes some other *Ahadīth* related to *Shām*.

Some beneficial footnotes compiled by me are marked as
translator's notes [TN] to further aid the readers in their pursuit
of seeking the reality of this topic. Although every effort has been
made to ensure this modern translation is as accurate as possible,
if there are any obvious errors in it, then I will be deeply grateful to
its readers to provide feedback and guidance.

I hope that this book benefits others. If so, then it is only a
blessing from Allāh, and then the product of guidance from my

3. [TN] *Saḥīḥ ul-Jami,'* Ḥadīth no.224.

teachers and encouragement of sincere friends. I also hope that with works like this, I can make a modest contribution to the right understanding of Islām. I sincerely ask Allāh to accept my meagre efforts in this regard. I ask Allāh to make this simple endeavour a source of pleasure for us all and a source of success in the Hereafter. O Allah, save the oppressed among the believers and Muslims in the land of *Shām*, and in the east and west of the Earth, O Most Merciful grant them relief and a way out from oppression. Āmīn.

Abū Ubaydah Arsalān Yūnus
Rabīᶜ uth-Thānī, 1445

Historical Background

The Breadth Of *Shām*

An insight of the early Islamic sources defines the geographic boundaries of *Shām* as modern day Palestine, Syria, Lebanon, southwest Turkey, northeast gradient of Egypt, parts of Jordan and potentially parts of northwest Saudi Arabia.

The famous historian Yaqūt al-Hamawī, when defining the boundaries of *Shām*, stated,

> It is from the Euphrates till al-Arish near Egypt. As for its width, it is from both mountains of Tay [near modern day Ha'il in Saudi Arabia] from the direction of the Qiblah till the Mediterranean Sea, including whatever lands there are in that direction. Among the major cities within it are Manjib, Aleppo, Hama, Homs, Damascus, Jerusalem and al-Ma'ara, and on the coast are Antioch, Trippoli, Acre, Tyre, Asqalan and others...[1]

Syria, *Suriya* and Assyria

What we now call Syria in English has its original name in Arabic as *Suriya*. The Greeks called it *Syrioi*. This name is derived from the ancient name called Assyria. Thousands of years ago this was a combination of Iraq, western Iran, south eastern and central Turkey, Lebanon, Jordan, Palestine, northern Egypt and modern day Syria. Its capital was located in Iraq along the Tigris River in Assur.

Modern day Syria on the other hand is an Islamic country in West Asia. This has been the official name since the 1st World War (1914-18).

1. [TN] *Mu'jam al-Buldān* by Yaqūt al-Hamawī vol.3, p.312. Additionally other potential areas of *Shām* include Tabūk and Dumat ul-Jandal, etc. see *Ithat al-Akhisa Bī Fadha'il al-Masjid al-Aqsa* vol.2, p.132.

Shāmin, Shām and Aram

The ancient Arabs used to call Assyria with the name of *Shāmin* or *Shām* which is attributed to Sam, the son of Prophet Nūh (﷽), whose descendants are thought to have settled here. Hence it was called *Shām* since the beginning of the Islamic era. Its other ancient name was *Iram* or *Aram* which was the name of the son of Sam b. Nūh (﷽).

Abū 'Abdullāh (Imām Bukhārī) said, *Shām* was called so because it is situated to the left of the Ka'bah.[2]

Ancient Civilisations

Around 10,000 BC the city of Jericho was founded and is located in modern day West Bank. Around 5000 BC the *Ghassulians* were migrating into Palestine and developing permanent villages as well as efficient agricultural techniques. Around 2500 BC the Ebla Kingdom was a significant area covering northern *Shām*. A recent discovery of 20,000 plaques shows traces of trade relations between Ebla and Egypt.

The Palestine Exploration Fund (PEF) founded in London 1865 is the oldest organisation in the world created specifically for the study of the area called *Shām*. With their efforts and practical work of excavations a lot of information regarding the inhabitants of this area has come to light. Some excavations have revealed traces of a period in which people lived only on hunting and were cave dwellers. These people also used to burn their dead which is the custom of the Aryans and they appear to be have been the Horites or Horams, ancestors of the Edomites, that migrated from the Arabian peninsula. Therefore some scholars believe that these are the original inhabitants of Canan and Palestine.

Ibrahim (﷽) In *Shām*

Around 2000–1800 BC, Ibrahim (﷽) came to Haran (Turkey) from Iraq. Then he migrated from Haran to a city in northern *Shām* called Halab (Aleppo) and it is said that because of his distribution of milk here this city was named Halab (Milk). After that he moved to Palestine from Halab.

2. [TN] *Sahīh Bukhārī Hadīth* no.3499.

Cananites To The Babylonian (Chaldean) Empire

Between 2000–1000 BC *Shām* was occupied by the Cananites, who were an Arab tribe that came from the Arabian Peninsula. The Cananites called the outsiders who migrated from Ur, Mesopotamia, as *Abus* or *Abram* (literally meaning on the other side). Meaning, those coming from the other side of the Euphrates and Jordan river. This word later became *Herio* meaning Hebrew. The arrival of the Hebrews here is implied in their name itself. Then the Phoenicians and Egyptians occupied it. After them the Aramaic, Assyrian and Babylonian (Chaldean) occupied here.

After 1450 BC, Damascus was ruled by the Egyptians. Around 1200 BC during the course of the Trojan war the Greek civilisation collapsed and one of their communities called the Philistines established themselves on the coast of Canan in Palestine. It is said that the word Palestine is hence derived from the Greek word Philistine. Around 1000 BC the Kingdom of Sulaymān ('🕊) included the areas from the Gulf of Aqaba to the Euphrates River.

The Babylonian (Chaldean) King Nebuchadnezzar conquered *Shām* in the early 6th century BC. In the middle of the 6th century BC, Cyrus the Greek King of Persia, conquered Sham.

After that around 300 BC Alexander conquered *Shām*. It then became part of the Greek Slovak Empire, founded by Alexander's General Slav whose capital was in Antioch.

Shām In The Roman Empire

Around 64 BC, the Romans conquered *Shām*. At that time, Antioch, with a population of 500,000, was the 3rd largest city in the Roman Empire after Rome and Alexandria. Alexander Severus, emperor of the Roman Empire, was a native of *Shām*. The Jupiter Temple of Jerusalem was built on the ruins of the 2nd Temple, which was destroyed by the Roman General Titus in 70 AD.

Queen Zenobia (Zaynab)

From the 1st to the 3rd century BC, there was an Arab Empire in the *Shām* city of *Tadmur* (Palmyra), which was a stronghold of the Roman Empire.

Tadmur was a famous oasis which became an important trading centre. It's ruler fought alongside the Romans against Persia. When he died, his queen, Zenobia, continued to run the government. In a short span of time, *Tadmur* gained independence from the Romans.

Christianity In *Shām*

Īsā (ﷺ) was born in Palestine at Nazareth during the reign of Augustus Caesar. People tried to crucify him but Allāh raised him alive to Heaven. After this, Christianity started to spread in *Shām*. When Caesar Constantine accepted Christianity in around 300 AD and moved the capital from Rome to Constantinople (modern day Istanbul) most of the population of *Shām* also accepted Christianity.

The Prophet ﷺ In *Shām*

During his adolescence the Prophet ﷺ went on a business trip with his uncle Abū Ṭālib to a city in *Shām* close to Damascus. It is said that a Christian Monk saw his mark of Prophethood and recognized that he is the awaited Prophet ﷺ. During his ﷺ later life he worked with Khadijah (ﷺ) and trader her goods during visits to *Shām*.

The Prophet ﷺ made the miraculous journey to the Heavens from the area of Masjid ul-Aqsa at Jerusalem. Praying *Ṣalāh* in Masjid ul-Aqsa is 250 times greater in reward than in other *Masājid* except for the Harām in Makkah and the Prophet ﷺ Masjid in Madinah.

Conquest Of *Shām*

Abū Ubaydah (ﷺ) with the commander Khalid b. Walīd (ﷺ) conquered Damascus during the Caliphate of ʾUmar (ﷺ) around 635 AD. He then went onto conquer the neighbouring cities around *Shām* such as Ba'labak, Homs, Aleppo and Antioch which is where the Caesar Heracles was situated. Then in 637 AD he conquered all the northern and coastal areas of Sham as well as *Bayt ul-Maqdis*, Jerusalem.

Around 638 AD Ṣuhayl b. Adi (ﷺ) conquered Iraq and then conquered the city of Raqa which is on the banks of the Euphrates river in *Shām*. Additionally, Iyāḍ b. Ghanam (Radī Allāhū ʾAnhu) conquered other cities in *Shām*.

Companions Buried In *Shām*

- Khalid b. Walīd, Nuʾmān b. Bashīr and Thawbān (﷽) are buried at Homs.
- Muʾāwiyah b. Sufyān and Dihya b. Kalbi (﷽) are buried at Damascus.
- Bilāl b. Rabah (﷽) is buried at Aleppo.
- Mūʾādh b. Jabal and Jaʾfar b. Abī Ṭālib (﷽) are buried around modern day Jordan.

Umayyad Dynasty

From 660-749 AD Damascus was the capital for the Umayyad dynasty. During this era Arabic became the official language and replaced Aramaic and Greek in *Shām*. The Hebrews also thought of the revival of their dead language, as a result of which the Hebrew language was saved again.

Christian scholars translated books on medicine, science and mathematics from Greek into Syriac which were then translated into Arabic. Cotton was used to make paper. This is evident based on discovering that a paper factory existed in Damascus in the 10th century.

Abbasid Dynasty

In 750 AD the Abbasid dynasty was established where the capital was located in Baghdad. This was after ʾAbdullāh b. ʾAlī entered Damascus and fought against the Umayyads thus taking over *Shām*.

Fatimid, Seljuk And Zangi Dynasty

The Banū Ṭūlūn captured *Shām* in 887 AD after which it was taking over by the Hamdanis. After that, the Fatimids took over around 977 AD and it was during their era that the Crusaders came and took control of *Shām*. Around 1128 AD the Zangis conquered Aleppo and then took control of Damascus in 1154 AD and saved it from being under control of the Crusaders.

Salāhudīn Ayūbī In *Shām*

After the death of the Zangi leader, Damascus was threatened by the Crusaders so Salāhudīn Ayūbī had come to Damascus from Egypt. Over the next few years they pushed the Crusaders back to the coast. In 1187 AD Salāhudīn Ayūbī freed and conquered Jerusalem from the Crusaders.

Mamlūk Dynasty

From 1250-1516 AD *Shām* was under control of the Mamlūks who had their capital at Cairo in Egypt.

Tatar Attacks And The Crusaders End In *Shām*

In 1260 AD Halaku Khān captured Aleppo and Damascus. However in the same year the Mamlūk general, Rukn ud-Din Baybars of Egypt, defeated the Tatars at Palestine and became the ruler of *Shām*, Egypt, Yemen and Ḥijāz.

Rukn ud-Din Baybars looked up to Salāhudīn Ayūbī and defeated the Crusaders from the coastal cities and forts of *Shām* to the point that they were never able to recover from their territorial losses.

Notable scholars during this era include Imams Ibn ʾAsākir, Dhahabī, Ibn Khalikān, Ibn Kathīr, Ibn Taymiyyah, Ibn ul-Qayim and Ibn Qudamah.

Ottoman Dynasty

In 1516 AD Salīm I, sensing the threat of the Portuguese Crusaders, began to remove the weak Mamlūk rulers from Sham and Egypt by defeating them. In the following year *Shām*, Egypt and Ḥijāz came under rulership of the Ottomans with their capital at Constantinople.

At the end of the 19th century the Ottomans connected Damascus and Constantinople by a railway line. In 1908 AD the Damascus to Madinah railway started running.

Shām In The 20th Century

The Balfour Declaration was issued by the British in 1917 which announced support for the establishment of Zionist people in Palestine. This is considered a principal cause of the ongoing issues in modern day Palestine. A year later during the 1st World War in October 1918 AD the British forces occupied *Shām*. Then, under an agreement in July 1920, the French Imperial Empire occupied parts of *Shām*.

After this, *Shām* became fragmented and broke up into independent territories. In 1946 Lebanon, Jordan and Syria declared independence. In 1947 the UN proposed a partition of Palestine. This has resulted in long lasting consequences and inflamed unnecessary conflict in which there is a clear prejudice of civil and religious rights of existing non-Zionist communities in Palestine.

Biography Of Imām Ibn ʿAbdil Ḥādī

Name

His name is Shams ud-Din Abū Abdillah Muḥammad b. Aḥmad b. ʿAbdul Ḥādī b. Qudamah Maqdisi al-Hanbalī.

Birth

He was born was born in the year 704 *Hijrī*.[3]

Teachers

He studied *Ḥadīth* with *Hafiḍh* Al-Mizi and remained in his company for 10 years. He became so skilled that Imām Dhahabī and his teacher Imām Al-Mizzi used to benefit from him.[4] He also benefited from Shaykh ul-Islām Ibn Taymiyyah and remained in his company for a long time.

Virtues

Ibn Kathīr said:

> He was the *Hafiḍh* the *Allamah*...he excelled in the sciences [of Islām]...he had a good understanding of religion with an authentic mind.[5]

3. [TN] *Al-Bidiyah Wan-Nihiyah* by Ibn Kathīr vol,14, p.211.

4. [TN] *Ad-Durar al-Kāminah* vol.3, p.331.

5. [TN] *Ad-Durar al-Kāminah,* vol.5, p.62.

His Books

Some of his famous books are:

- *Tabaqāt ʾUlemā Al-Ḥadīth* is a biography collection of Ḥadīth scholars.

- *Tanqīh Tahqīq Fī Ahadīth Taʾlīq* is a collection of evidences used by the *Hanabilah* and defines their authenticity or weakness.

- *As-Sārim ul-Munki Fī Rad Ala Subkī* is a refutation of as-Subkī regarding weak and fabricated *Ahadīth*. This book also covers visiting graves, Masjids and the Prophet ﷺ.

- *Al-Muharrar Fil Ḥadīth* is a summary of rulings of *Ḥadīth*.

Death

Imāms Ibn Kathīr and Dhahabī state that Ibn Abdil Ḥādī passed away on the 10th of Jamad ul-Ula 3 Hijrī at the age of 40 years after suffering from fever and boils for 3 months.[6]

6. [TN] *Ad-Durar al-Kāminah*, vol.5, p.62.

CHAPTER ONE
Āyāt And *Ahadīth* About The Virtues Of *Shām*

Allāh the Most High says,

$$\text{سُبْحَٰنَ ٱلَّذِىٓ أَسْرَىٰ بِعَبْدِهِۦ لَيْلًا مِّنَ ٱلْمَسْجِدِ ٱلْحَرَامِ إِلَى ٱلْمَسْجِدِ ٱلْأَقْصَا ٱلَّذِى بَٰرَكْنَا حَوْلَهُۥ}$$

Glory be to the One Who took His servant ⸢Muḥammad⸣ by night from the Sacred Masjid to the Farthest Masjid whose surroundings We have blessed... [Sūrah Al-Isra, āyah no.1][7]

Allāh the Most High says,

$$\text{وَلِسُلَيْمَٰنَ ٱلرِّيحَ عَاصِفَةً تَجْرِى بِأَمْرِهِۦٓ إِلَى ٱلْأَرْضِ ٱلَّتِى بَٰرَكْنَا فِيهَا ۚ وَكُنَّا بِكُلِّ شَىْءٍ عَٰلِمِينَ}$$

And to Solomon [We subjected] the wind, blowing forcefully, proceeding by his command toward the land which We had blessed... [Sūrah Al-Anbiya, āyah no.81][8]

And Mūsā (ﷺ) said to his people,

$$\text{يَٰقَوْمِ ٱدْخُلُوا۟ ٱلْأَرْضَ ٱلْمُقَدَّسَةَ ٱلَّتِى كَتَبَ ٱللَّهُ لَكُمْ وَلَا تَرْتَدُّوا۟ عَلَىٰٓ أَدْبَارِكُمْ فَتَنقَلِبُوا۟ خَٰسِرِينَ}$$

O my people, enter the blessed land [i.e., Palestine] which Allāh has assigned to you... [Sūrah Al-Ma'idah, āyah no.21]

7. [TN] Imām at-Ṭabarī said, [the meaning of] "whose surroundings We have blessed" here, Allah is saying: of which We have made the surrounding area blessed for its inhabitants in their livelihoods, food, tilling and planting. See *Tafsīr at-Ṭabarī*, vol.14, p.448.

8. [TN] The commentators of the Qur'ān have agreed that this refers to the land of *Shām*. See *Tafsīr at-Ṭabarī* vol.17, p.55 and *Tafsīr Ibn Kathīr* vol.3, p.188.

Allāh the Most High says,

<div dir="rtl">

وَنَجَّيْنَهُ وَلُوطًا إِلَى ٱلْأَرْضِ ٱلَّتِي بَرَكْنَا فِيهَا لِلْعَلَمِينَ

</div>

**And We delivered him and Lot to the land which
We had blessed for the worlds [i.e., peoples].
[Sūrah Al-Anbiya, āyah no.71]**

ḤADĪTH 1

وروى نافع، عن ابن عمر ﷺ أن النبي ﷺ قال: اللهم بارك لنا في
شامنا، اللهم بارك لنا في يمننا، قالها مراراً، فلما كان في الثالثة، أو
الرابعة، قالوا: يا رسول الله، ففي عراقنا، قال: بها الزلازل والفتن، وبها
يطلع قرن الشيطان.

Nafi' narrates from Ibn ʾUmar (ﷺ) that the Prophet ﷺ said,

> O Allāh! Bless[9] for us our *Shām* and bless for us our
> Yemen.

He ﷺ said this many times, so when he ﷺ said it for the third or
fourth time, they [the people] said, O Messenger of Allāh, then [also]
in our Iraq? He ﷺ said,

> There will be earthquakes and tribulations by
> means of it, and the horn of Shaytān will come out
> from there.

9. [TN] Imām Ibn Rajab al-Hanbalī said, it should be understood that the
blessing in *ash-Shām* includes blessing in both religious and worldly matters.
Hence the land is called blessed. *Majmuʿah Rasaʾil Ibn Rajab* vol.3, p.224.

This *Ḥadīth* is *Saḥīḥ*. It was reported by Bukhārī[10], Tirmidhī[11] and Ṭabarānī[12]. [The words in the *Ḥadīth* are from Ṭabarānī].

10. [TN] *Saḥīḥ Bukhārī Ḥadīth* no.1037. In the wording of Bukhari there is the word *Najd* in the same place of Iraq. The word *Najd* in this context is synonymous with the word Iraq.

Imām Ibn ul-Athīr mentions that Najd is not the name of a place but rather refers to the highland region beyond *Hijaz* towards Iraq. *An-Nihiyah* vol.5, p.18.

Imām Ibn Ḥajar mentions that Al-Khaṭābī said, the *Najd* is in the direction of the East, and for the one who is in Madinah then his *Najd* would be the desert of Iraq and its regions for this is to the east of the people of Madinah. The basic meaning of *Najd* is that which is raised or elevated from the Earth in contrast to *al-Gawr* for that is what is lower than it. *Tihama* [the coastal plain along the south western and southern shores of the Arabian Peninsula] is entirely *al-Gawr* and Makkah is in *Tihamah*. *Fath ul-Bari* vol.13, p.58.

11. [TN] This *Ḥadīth* is *Saḥīḥ*. *Sunan at-Tirmidhī Ḥadīth* no.3953.

12. [TN] This *Ḥadīth* is *Saḥīḥ*. *Muʾjam al-Kabīr of at-Ṭabarānī* vol.12, p.384.

ḤADĪTH 2

وعن أبي الدرداء ﷺ قال : قال رسول الله ﷺ : بينا أنا نائم إذ رأيت
عمود الكتاب احتمل من تحت رأسي، فظننت أنه مذهوب به،
فأتبعته بصري فعمد به إلى الشام، ألا وإن الإيمان حين تقع الفتن
بالشام .

Abu Dardā (ﷺ) narrated that the Messenger of Allāh ﷺ said,

> While I was sleeping, I saw [in a dream] as if the
> *Amud*[13] (pillar, column or spine) of the Book was
> carried from beneath my head. So I thought it was
> being taken, consequently I followed it with my sight
> and it was taken to *Shām*. Lo, indeed *Īmān* will be in
> *Shām* at the time when the tribulation occurs."[14]

It has been narrated by Imam Ahmad[15] and other than him. Al-

13. [TN] Imām Ibn Ḥajar said that, the meaning of *Amud* (pillar, column, spine)
when seen in a dream, it is the saying of the scholars of dream interpretation
they say whoever sees an *Amud* in a dream then it represents the religion,
or a man relied upon in it, and they interpret the *Amud* with religion and
authority. *Fatḥ ul-Bari* vol.12, p.403

14. [TN] Imām Ibn Taymiyyah said that, the pillar of the book and Islām, this
refers to something that acts as a support; what is referred to here is those
who learn the Qur'an and adhere to it. This is similar to the words of the
Prophet ﷺ, that the heartland of the believers is ash-*Shām*, [see *Musnad
Ahmad* vol.4, p.104, *Sunan an-Nasā'ī Ḥadīth* no.3561, classed as *Sahīh* by Shaykh
Albānī. See *Silsilah Ahadith As-Sahīhah Ḥadīth* no.1935]. *Majmū' ul-Fatāwā*, vol.27,
p.42

 In this *Ḥadīth* the Prophet ﷺ is shown through a dream the Book's pillar
meaning that it is a sign of the end of *Īmān*. This type of sign is one of the
signs of the coming of the Day of Judgement so the Prophet ﷺ encouraged
migration to *Shām* at the end of time where there will be *Īmān* in *Shām*. It
should be noted that the Prophet's ﷺ dream is true and it is also a type
of revelation. Imam Al-Qurtubī explains in *At-Taḏhkirah* that perhaps these
tribulations are what will occur when *Dajjāl* emerges and Allāh knows best.

15. [TN] This *Ḥadīth* is Sahih. *Musnad Ahmad* vol.36, p.62 *Ḥadīth* no.21733. See

Imām Al-*Hafiḍh* Abū 'Abdullāh[16] said, this *Ḥadīth* is well-known and in my opinion its *Sanad* is of the standard of Bukhārī and Allāh knows best.

Sahih At-Targhīb Wat-Tarhīb Ḥadīth no.3094 and *Takhrīj Ahadith Fadha'il Ash-Shām Wa Dimishq* by Shaykh Albānī p.12.

16. [TN] He is Al-Hafiḍh Diya ud-Din al-Maqdisi the author of *Al-Ahadith al-Mukhtārah*.

ḤADĪTH 3

وروى الطبراني عن عبد الله بن عمرو ﵄، أن النبي ﷺ قال: رأيت
في المنام أخذوا عمود الكتاب، فعمدوا به إلى الشام، فإذا وقعت
الفتن فالأمن بالشام.

Imam Tabarānī reported from Abdullah b. 'Amr (﵄) that the
Prophet ﷺ said,

> I saw in a dream that the *Amud* (pillar, column or
> spine) of the Book has been taken and it was moving
> towards *Shām*. So when the tribulations occur then
> there will be *Īmān* in *Shām*.[17]

17. [TN] The *Ḥadīth* is *Sahīh. Al-Mu'jam Al-Awsat of At-Tabarānī* vol.3, p.127,
Ḥadīth no.2689. See *Sahīh At-Targhīb Wat-Tarhīb Ḥadīth* no.3092 and *Takhrīj
Ahadith Fadha'il Ash-Shām Wa Dimishq* by Shaykh Albānī p.31.

ḤADĪTH 4

وروى أيضاً، عن أبي أمامة ﷺ عن النبي ﷺ قال: رأيت عمود
الكتاب انتزع من تحت وسادتي، فأتبعته بصري، فإذا هو نور ساطع
حتى ظننت أنه قد يهوى به، فعمد به إلى الشام وإني أولت أن الفتن
إذا وقعت أن الإيمان بالشام.

Similarly it is narrated from Abu Ūmāmah (ﷺ) from the Prophet
ﷺ that,

> I saw the *Amud* (pillar, column or spine) of the book
> being pulled from under my pillow, consequently I
> followed it with my sight and lo and behold it was
> a shining light until I thought that I would fall in
> love with it. It was going towards *Shām* and indeed
> I interpreted it to mean that when the tribulations
> occur then *Īmān* will be in *Shām*.[18]

18. [TN] This *Ḥadīth* is *Ḍaʾīf Jiddan* due to the weakness of Ufayr b.Maʾdan in
the *Isnād*. *Al-Muʾjam Al-Kabīr* of Tabarānī vol.8, p.170, *Ḥadīth* no.7714. See *Ḥadīth*
no.3 for a similar wording that is *Sahīh*.

ḤADĪTH 5

وروى أيضاً، عن عبد الله بن حوالة ﷺ، قال : قال رسول الله ﷺ :
رأيت ليلة أسري بي عموداً أبيض كأنه لؤلؤة تحمله الملائكة، قلت : ما
تحملون؟ قالوا: عمود الإسلام، أمرنا أن نضعه بالشام، وبينا أنا نائمٌ،
رأيت عمود الكتاب اختلس من تحت وسادتي، فظننت أن الله قد
تخلى عن أهل الأرض، فأتبعته بصري، فإذا هو نور ساطع بين يدي،
حتى وضع بالشام. فقال ابن حوالة : يا رسول الله خر لي؟ قال : عليك
بالشام.

Similarly it is narrated from ᵓAbdullāh b. Hawalah (ﷺ) he said, that
the Messenger of Allāh ﷺ said,

> On the night of *Isra* I saw a white pillar which
> appeared to be made of pearls being carried by the
> Angels, I asked, what are you carrying?

> They replied, the *Amud* (pillar, column or spine) of
> Islam, and we have been commanded to place it in
> *Shām*.

> [The Prophet ﷺ continued], Whilst I was sleeping
> I saw a pillar of the book that was taken from
> beneath my pillow and I thought Allāh has forsaken
> the people of the Earth. Consequently I followed it
> with my sight and there was a light shining before
> me until it was placed in *Shām*.

ᵓAbdullāh b. Hawalah (ﷺ) said, O Messenger of Allāh ﷺ, chose for
me [a place to go when this happens]. He ﷺ said, "Stick to [and go
to] *Shām*."[19]

19. [TN] This Ḥadīth is *Daᶜīf*. *Musnad Ash-Shamiyin of Tabarānī* vol.1, p.345. See
Daᶜīf At-Targhib Wat-Tarhib Hadith no.1806. See Ḥadīth no.3 for a similar wording
that is *Sahīh*.

ḤADĪTH 6

روي أيضاً من رواية عفير بن معدان، عن سليم بن عامر، عن أبي أمامة ﷺ، عن النبي ﷺ قال: الشام صفوة الله من بلاده، إليها يجتبي صفوته من عباده، فمن خرج من الشام إلى غيرها فبسخطه، ومن دخلها من غيرها فبرحمته.

Similarly it is narrated from Ufayr b. Ma'dan, from Salim b. Amir, from Abū Ūmāmah (ﷺ), from the Prophet ﷺ that he said,

> *Shām* is from one of Allāh's chosen lands, to which His chosen servants will be drawn to. So whoever moved out of *Shām* to some other place (or country) then he is in Allāh's displeasure, and the one who entered *Shām* from some other place (or country) then he is in Allāh's mercy.[20]

20. [TN] This *Ḥadīth* is *Daʿīf Jiddan*. *Al-Muʿjam Al-Kabīr* of *Ṭabarānī* vol.8, p.171. See *Daʿīf At-Targhīb Wat-Tarhīb Ḥadīth* no.1807. There is a similar *Ḥadīth* which is *Saḥīḥ* that states Abū Ūmāmah (ﷺ) said that the Messenger of Allāh ﷺ said, "The chosen land of Allāh is *Shām* and in it are His chosen people and servants. A group from my nation will certainly enter Paradise without any reckoning or punishment." See *Silsilah As-Saḥīḥah Hadith* no.1909 and *Saḥīḥ ul-Jami' Ḥadīth* no.3765.

ḤADĪTH 7

وقال الإمام أحمد: حدثنا عبد الصمد، حدثنا حماد، عن الجريري،
عن أبي المشاء -وهو لقيط بن المشاء-، عن أبي أمامة رضي الله عنه
قال: لا تقوم الساعة حتى يتحول خيار أهل العراق إلى الشام،
ويتحول شرار أهل الشام إلى العراق.

وقال رسول الله ﷺ: عليكم بالشام.

Imām Aḥmad said, Abdusamad narrated to us, Ḥammād narrated
to us, from Juriri, from Abul Masha' - and he is Laqit b. al-Masha',
from Abū Ūmāmah (ؓ) that he said,

> The Hour will not be established until the good
> people of Iraq move to *Shām* and the evil people of
> *Shām* move to Iraq.[21]

And the Messenger of Allah ﷺ said, "Stick to [and go to] *Shām*."[22]

21. [TN] This *Athar* is *Saḥīḥ. Musnad Ahmad* vol.36, p.461 and *Musanaf Ibn Abi Shaybah* no.37739.

22. [TN] This *Ḥadīth* is *Saḥīḥ. Musnad Ahmad* vol.36, p.461 and *Al-Muʾjam Al-Kabīr of Ṭabarānī* vol.19, p.420.

ḤADĪTH 8

وعن خريم بن فاتك الأسدي صاحب رسول الله ﷺ ، أنه سمع رسول
الله ﷺ يقول : أهل الشام سوط الله في أرضه، ينتقم بهم ممن يشاء من
عباده، وحرام على منافقيهم أن يظهروا على مؤمنيهم، ولا يموتوا إلا
هماً، وغماً، وغيظاً، وحزناً.

Khuraym b. Fatik al-Asadi (ﷺ), a companion of the Messenger of
Allāh ﷺ, said that he heard the Messenger of Allāh ﷺ say,

> The people of *Shām* are Allāh's whip on the Earth. He
> takes vengeance through them however he wishes.
> It is impossible for their hypocrites [from the people
> of *Shām*] to prevail over the believers and they [the
> hypocrites] would never die except in a state of
> distress, rage, or sorrow [anxiety].

In the same way, it has been reported by At-Tabarānī[23] in *Marfūʾ*
[form]. Imām Aḥmad and Abū Yaʿla al-Mawṣilī[24] reported it in
Mawqūf [form].[25]

23. [TN] *Al-Muʾjam Al-Kabīr* vol.4, p.209, Ḥadīth no.4163. This Ḥadīth in *Marfūʾ*
[form] is *Daʾīf*. See *Daʾīf At-Targhīb Wat-Tarhīb* Ḥadīth no.1811 and *Silsilah Ad-*
Daʾifah of Shaykh Albānī Ḥadīth no.13 however the text is *Sahīh* due to the
narration being in *Musnad Ahmad* with a *Hasan Isnād*.

24. [TN] *Musnad Abu Yaʿla* as mentioned in *Ath-Thiqāt* by Ibn Hibban vol.4, p.28.

25. [TN] This Ḥadīth is *Sahīh* in *Mawqūf* [form]. *Musnad Ahmad* vol.25, p.467. In
this Ḥadīth , Allāh has called the people of *Shām* His weapon and has given the
believers of the people of *Shām* dominion over the hypocrites. Additionally,
He said that those hypocrites who harass my believing servants will die in a
state of grief and anxiety.

ḤADĪTH 9

وعن معاوية بن قرة، عن أبيه ﷺ قال: قال رسول الله ﷺ: إذا فسد
أهل الشام فلا خير فيكم، لا تزال طائفة من أمتي منصورين، لا يضرهم
من خذلهم حتى تقوم الساعة.

From Mu'āwiyah b. Qurah. from his father (ﷺ) he said, the Messenger of Allāh ﷺ said,

> When the people of *Shām* become corrupt there is no good in you. There will always be a group of my Ummah who will be victorious [through Allah's help], and they will not be harmed by those who seek to humiliate them until the hour comes.

Reported by Al-Imām Aḥmad[26], Abū Ya'lā Mawṣilī[27], Ibn Mājah[28] and Tirmidhī[29] who said [this is a] *Hasan Saḥīḥ Ḥadīth*.[30]

26. [TN] This *Ḥadīth* is *Saḥīḥ*. *Musnad Ahmad* vol.33, p.472, *Ḥadīth* no.20361.

27. [TN] This *Ḥadīth* is not found in *Musnad Abu Ya'la*.

28. [TN] *Sunan Ibn Mājah Ḥadīth* no.6 in a summarised form.

29. [TN] *Sunan At-Tirmidhī Ḥadīth* no.2192.

30. [TN] This *Ḥadīth* is present in various different books with minor differences. The words "When the people of *Shām* become corrupt there is no good in you..." refers to the people of *Shām* who will suffer from this tribulation and corruption, however there will be a group on the truth who will receive the help of Allāh. The following are the sayings of the scholars of

ḤADĪTH 10

وعن عمير بن هانئ، عن معاوية بن أبي سفيان ﷺ، أنه خطبهم قال :
سمعت رسول الله ﷺ يقول : لا تزال طائفة من أمتي قائمة بأمر الله،
لا يضرهم من خذلهم، ولا من خالفهم حتى يأتي أمر الله وهم على
ذلك.

قال عمير : قال مالك بن يخامر : يا أمير المؤمنين، سمعت معاذاً يقول :
هم بالشام.

From Umayr b. Hani, from Mu'āwiyah b. Abū Sufyān (ﷺ) that he
heard the Messenger of Allāh ﷺ saying during a sermon,

> There will continue to be a group from my Ummah
> that shall uphold Allāh's religion. They will not be
> harmed by those who forsake or oppose them and
> they shall remain in that state [of dominance] until
> Allāh's command [the Day of Judgment] arrives.

= Ḥadīth regarding this group:

Imām Bukhari narrates from his Shaykh Imām Ali b. Madini that they are
the *Ashab ul-Ḥadīth* [the people of Hadith]. (*Tirmidhī Ḥadīth* no.2192)

Imām Ahmad b. Hanbal said that if the Ahlul Ḥadīth are not meant by this
group, then I do not know who is meant.

Qadhī Iyāḍ said, the intended meaning of Imām Ahmad is *Ahlus Sunnah
Wal Jama'ah* and those people who follow the methodology of the *Ahlul Ḥadīth*.

Imām Nawawī said that, it is possible that this group consists of several
groups of believers, such as the brave, those who have insight, the *Fuqahā*,
the scholars of Ḥadīth, the scholars of *Tafsīr*, the ones who enjoin good and
forbid evil, the ascetic and the worshipper, and it is not necessary for them
to be gathered in one area. *Fath ul-Bārī* vol.1, p.164

Allāh has granted the Ummah of Muḥammad ﷺ the honor that it will not
be completely misled in the same way as the previous ones were misled so
that none of them remained on the straight path. Rather there will always be
a group from the Ummah who will be on the straight path.

Umayr said, Mālik b. Yukhamir said,

> O Amir ul-Mu'minin, I heard Mūʾādh saying, they are in *Shām*.

Reported by Bukhārī[31] and other than him.[32]

31. [TN] *Saḥīḥ Bukhārī Ḥadīth* no.3641.

32. [TN] *Saḥīḥ Muslim Ḥadīth* no.1037.

ḤADĪTH 11

ورواه محمد بن كثير، عن الأوزاعي، عن قتادة، عن أنس ﷺ قال :
قال رسول الله ﷺ : لا تزال طائفة من أمتي يقاتلون على الحق،
ظاهرين إلى يوم القيامة ، وأومأ بيده إلى الشام.

Reported by Muḥammad b. Kathīr, from al-Awza'i, from Qatādah,
from Anas (ﷺ) he said, the Messenger of Allāh ﷺ said,

> A group of people from my Ummah will continue
> to fight in defence of truth and remain triumphant
> until the Day of Judgment.

He ﷺ pointed towards *Shām* with his hand.

Reported by *Hafiḍh* Abū 'Abdullāh [Ḍiya ud-Din al-Maqdisi] with his
Isnād[33]. The well-known report [is] Qatādah. From Mutarif, from
Imran[34] and Allāh knows best.

33. [TN] This *Isnād* is *Da'īf Jiddan*. *Al-Ahadīth ul-Mukhtārah*, vol.7, p.97, Ḥadīth
no.2511. The main two reasons for the *Isnād* being *Da'īf Jiddan* is because, 1.
Muḥammad b. Kathīr and Qatādah are both *Mudallis* narrators and they
are narrating this with the word "from"; 2. Muḥammad b. Kathīr has been
criticised by various Imams. See *Mizan ul-I'tidal*, vol.6, p.331. Although this
Isnād is not *Saḥīḥ* the same wording of the *Ḥadīth* without the words "He ﷺ
pointed towards *Shām* with his ﷺ hand" is similar to other *Saḥīḥ Ḥadīth* such
as the one narrated by Jābir b. Abdullah (ﷺ) in *Saḥīḥ Muslim*, Ḥadīth no.1923.

34. [TN] This *Ḥadīth* is *Saḥīḥ*. *Musnad Aḥmad* vol.33, p.83 and *Sunan Abū Dāwūd*
Ḥadīth no.2484.

ḤADĪTH 12

وعن أبي صالح الخولاني، عن أبي هريرة ﷺ، عن رسول الله ﷺ قال:
لا تزال طائفة من أمتي يقاتلون على أبواب دمشق وما حوله، وعلى
أبواب بيت المقدس وما حوله، لا يضرهم خذلان من خذلهم، ظاهرين
على الحق إلى أن تقوم الساعة.

Abū Ṣāliḥ Khawlani, from Abū Hurayrah (ﷺ), from the Messenger of Allāh ﷺ who said,

> A group of my Ummah will always fight in and around the gates of Damascus, and in and around *Bayt ul-Maqdis*. They will not be harmed by those who forsake them. They will prevail over the truth until the Day of Judgment is established.

Reported Abul Qasim b. Sulaymān b. Aḥmad Al-Lakhmi.[35]

35. [TN] This Ḥadīth is *Daʾīf Jiddan. Al-Muʾjam Al-Awsaṭ* vol.1, p.19, Ḥadīth no.47. The Ḥadīth is *Daʾīf Jiddan* because both Walīd b. Abad and Abū Ṣāliḥ al-Khawlani are *Majhul* narrators. *Takhrij Ahadith Fadhaʾil Ash-Shām Wa Dimishq* by Shaykh Albani p.64.

ḤADĪTH 13

وقال الإمام أحمد في مسنده: حدثنا هاشم، قال: حدثنا عبد الحميد،
قال: ثنا شهر بن حوشب، قال: حدثتني أسماء بنت يزيد، أن أبا ذر
الغفاري، كان يخدم النبي ﷺ، فإذا فرغ من خدمته آوى إلى المسجد،
فكان هو بيته يضطجع فيه، فدخل رسول الله ﷺ ليلة، فوجد أبا ذر
نائماً منجدلاً في المسجد، فنكته رسول الله ﷺ برجله حتى استوى
جالساً، فقال له رسول الله ﷺ: ألا أراك نائماً؟ فقال أبو ذر: يا رسول
الله فأين أنام؟ هل لي من بيت غيره؟ فجلس إليه رسول الله ﷺ، فقال
له: كيف أنت إذا أخرجوك منه؟ قال: إذاً ألحق بالشام، فإن الشام
أرض الهجرة، وأرض المحشر، وأرض الأنبياء، فأكون رجلاً من أهلها،
قال له: كيف أنت إذا أخرجوك من الشام؟ قال: إذاً أرجع إليه
فيكون هو بيتي ومنزلي، قال له: كيف أنت إذا أخرجوك منه الثانية
؟ قال: إذاً آخذ سيفي فأقاتل عني حتى أموت، قال: فكشر إليه
رسول الله ﷺ فأثبته بيده، قال: أدلك على خير من ذلك ؟ قال:
بلى، بأبي أنت وأمي يا نبي الله، قال رسول الله ﷺ: تنقاد لهم حيث
قادوك، وتنساق لهم حيث ساقوك، حتى تلقاني وأنت على ذلك.

Imām Aḥmad [narrated] in his *Musnad*, Hashim narrated to us he
said, Abdulhamid narrated to us he said, Shahr b. Hawshab narrated
to us he said, Asma Bint Yazīd narrated to us:

> Abū Dhar Ghifari (ؓ) used to serve the Prophet ﷺ.
> So when he used to finish serving him, he would
> come to the Masjid and that Masjid was his house in
> which he used to sleep.

> So one night the Prophet ﷺ entered the Masjid,
> and he found Abū Dhar (ؓ) lying on his side in
> the Masjid. Subsequently the Messenger of Allāh
> ﷺ shook him with his foot, so he sat up straight.
> The Messenger of Allāh ﷺ said to him: What is your
> assessment about sleeping?

So Abū Dhar (🙏) said: O Messenger of Allāh 🙏 where shall I sleep, do I have any other house besides this?

So the Messenger of Allāh 🙏 sat down with him and said to him: What will happen to you when you are expelled from it? He replied, I will go to *Shām*. Indeed, *Shām* is the land of emigration, the land of assembly and the land of the Prophets, so I will also become one of its inhabitants.

So he 🙏 said to him: Then what will you do when you are expelled from there [*Shām*] as well? So he replied, I will return again [to Madinah] for it is my home and my dwelling.

He (🙏 said to him: Then what will you do when you are expelled from here (Madinah) for the second time as well? So he replied, I will then take my sword and fight with my life until I die. Hearing this, the Messenger of Allāh 🙏 placed his hand on his shoulder and said, shall I tell you something better than that? Abū Dhar (🙏) replied, yes indeed [please do so] may my parents be sacrificed for you O Prophet of Allāh.

The Messenger of Allāh 🙏 said, do your best, go wherever they lead you, even if your ruler is an Abyssinian slave, until you meet me [in the hereafter] in that condition.[36]

36. [TN] In this *Ḥadīth* there is a conversation between the Messenger of Allah 🙏 and Abu Dhar Ghifari (🙏) in which he 🙏 wanted to know how much patience he could endure after people drive him out of the localities. This is because those who follow the religion of Allāh and the Sunnah of the Messenger of Allāh 🙏 are usually harassed by Shaytān and his followers. The concluding advice of the Prophet 🙏 was such that he stated the best thing which Abū Dhar (🙏) could do is do his best in following the religion and continue to obey the Muslim rulers in those things which they are to obeyed in in order to prevent unnecessary anarchy.

Imām Aḥmad[37] reported it like this and it's *Isnād* is *Hasan*, Allāh knows best.

37. [TN] *Musnad Aḥmad* vol.45, p.568 and it's *Isnād* is *Daʾīf* due to the condition of Shahr b. Hawshab. However the *Ḥadīth* is *Hasan Li-Ghayrihi* due to other similar narrations. See *Al-Muʾjam Al-Kabīr* vol.2, p.148, *Al-Hilyah* vol.1, p.352, *Musnad Aḥmad* vol.35, 338 and *Sunan Ibn Mājah Ḥadīth* no.2862.

ḤADĪTH 14

<div dir="rtl">

وقال محمد بن يحيى الذهلي: حدثنا محمد بن كثير الصنعاني، عن معمر، عن الزهري، عن صفوان بن عبد الله بن صفوان، قال: قام رجل يوم صفين، فقال: اللهم العن أهل الشام، فقال علي: مه، لا تسب أهل الشام جماً غفيراً، فإن فيهم الأبدال.

</div>

Muḥammad b. Dhuhali said, Muḥammad b. Kathīr As-San'ani narrated to us, from Ma'mar, from Az-Zuhri, from Safwan b. 'Abdullāh b. Safwan he said,

> On the day of [the Battle of] Sifin, a man stood up and said, O Allāh curse the people of *Shām*. So 'Alī (؈) said, do not abuse the people of *Shām* much, for the Abdal are in it.

Zuhri narrated it from Safwan in *Mawqūf* form like this.[38]

38. [TN] This *Athar* is *Da'īf* due to Muḥammad b. Kathīr being *Da'īf*. See *Mizan Ul-I'tidal* vol.4, p.18-19. *Al-Ahadīth Ul-Mukhtārah* vol.2, p.111.

ḤADĪTH 15

وقد رواه الإمام أحمد بن حنبل في مسنده من وجه آخر مرفوعاً،
قال : حدثنا أبو المغيرة، حدثنا صفوان، حدثني شريح -يعني ابن عبيد،
قال : ذكر أهل الشام عند علي بن أبي طالب ﷺ وهو بالعراق فقالوا :
العنهم يا أمير المؤمنين، قال : لا، إني سمعت رسول الله ﷺ يقول :
الأبدال يكونون بالشام، وهم أربعون رجلاً، كلما مات رجل أبدل الله
مكانه رجلاً، يسقى بهم الغيث، وينتصر بهم على الأعداء، ويصرف
عن أهل الشام بهم العذاب .

Indeed it has been reported by Imām Aḥmad b. Hanbal in his
Musnad from another way [Isnād] in *Marfūʾ* form. He said Al-Mughira
narrated to us he said, Safwan narrated to us he said, Shūrayh
narrated to me i.e. Ibn Ubayd, he said:

> The people of *Shām* were mentioned in front of ʾAlī b.
> ʾAlī Ṭālib (ؓ) when he was in Iraq. So the people said,
> curse them O Commander of the believers. So he said,
> no, indeed I heard the Messenger of Allāh ﷺ saying,
> "The Abdal will be in *Shām* and they shall be 40 men.
> When one of them dies Allāh places another man in
> his place. Through them [i.e. their *Duas*] the rain is
> sent, victory is achieved against the enemies and the
> punishment is warded off from the people of *Shām*."

The narrators of the Ḥadīth are *Thiqah* however it is *Munqatiʾ* because
Shūrayh b. Ubaydah did not meet ʾAlī (ؓ). Hafidh Abū ʾAbdullāh said,
I have not found any Ḥadīth with a better *Mutasil Isnād* mentioning
the Abdal than this aforementioned Ḥadīth. He [Abū ʾAbdullāh]
stated this. Allāh knows best.[39]

39. [TN] This Ḥadīth is *Munkar* and the *Isnād* is *Daʾīf*. *Musnad Aḥmad* vol.2, p.231
and *Al-Ahadīth Ul-Mukhtārah* vol.2, p.110. See *Silsilah Ad-Daʾifah* of Shaykh
Albānī Ḥadīth no.936.

ḤADĪTH 16

وعن [ابن عمر] ﷺ أن النبي ﷺ قال : دخل إبليس العراق فقضى فيها حاجته، ثم دخل الشام فطردوه، ثم دخل مصر، فباض فيها، وفرخ، وبسط عبقريه.

[Ibn ᵓUmar][40] (ﷺ) said that the Prophet ﷺ said,

> Iblis entered Iraq, then he fulfilled his needs there, then he entered *Shām*, then he was reprimanded from there. Then he entered Egypt, where he laid eggs, hatched children and spread disciples.

Reported by At-Ṭabarānī.[41]

40. [TN] The original text states Imran b. Ḥusayn (ﷺ) however this is a mistake of the scribe which has been corrected from *Fadha'il Ush-Shām* of As-Samᵓāni *Ḥadīth* no.10

41. [TN] This *Ḥadīth* is *Daᵓīf Jiddan* because a narrator in the *Isnād* called Ibn Lahiyah is *Daᵓīf*. *Al-Muᵓjam Al-Kabīr* vol.12, p.261.

ḤADĪTH 17

<div dir="rtl">

وعن أبي الدرداء ﷺ، أن رسول الله ﷺ قال : فسطاط المسلمين يوم
الملحمة، بالغوطة إلى جانب مدينة يقال : لها دمشق.

</div>

Abū Dardā (�halla) said that the Messenger of Allāh ﷺ said,

> The camp of the Muslims on the day of the great
> battle is *Al-Ghuta* near a city called Damascus. It is
> among the best cities of *Shām*.

Reported by Aḥmad[42], Abū Dāwūd[43] and Ṭabarānī.[44]

42. [TN] This Ḥadīth is Ṣaḥīḥ. See *Saḥīḥ At-Targhīb Wat-Tarhīb Ḥadīth* no.3097.
Musnad Aḥmad vol.36, p.56. *Takhrij Ahadith Fadha'il Ash-Shām Wa Dimishq* by
Shaykh Albani p.67.

43. [TN] *Sunan Abū Dāwūd Ḥadīth* no.4298.

44. [TN] *Mu'jam Al-Awsaṭ Ḥadīth* no.3229.

ḤADĪTH 18

وعن عوف بن مالك ﷺ قال : أتيت النبي ﷺ ، وهو في خباء له،
فسلمت عليه، فقال : عوف بن مالك؟ فقلت : نعم، فقال : ادخل،
فقلت : أكلي أو بعضي؟ فقال : بل كلك، فقال : يا عوف بن مالك
اعدد ستاً بين يدي الساعة : أولاهن موتي، فاستبكيت حتى جعل
يسكتني، ثم قال : قل إحدى، فقلت : إحدى، والثانية : فتح بيت
المقدس، قل ثنتان، فقلت : ثنتان، قال : والثالثة : موتانٌ تكون في
أمتي، تأخذهم مثل نعاس الغنم، قل : ثلاث، فقلت : ثلاث، فقال :
والرابعة : فتنة تكون في أمتي، وعظمها، ثم قال : قل أربع ، فقلت :
أربع، فقال : والخامسة : يفيض فيكم المال، حتى إن الرجل ليعطى
المائة دينار، فيسخطها، قل خمس، فقلت : خمس، فقال : والسادسة :
هدنة بينكم، وبين بني الأصفر، فيسيرون على ثمانين غاية، تحت كل
غاية اثنا عشر ألفاً، فسطاط المسلمين يومئذ في أرض يقال : لها
الغوطة، في مدينة يقال لها دمشق .

Awf b. Mālik (ﷺ) said,

> I came to the Prophet ﷺ and he was in in his tent. So
> I greeted him with Salām and he said, are you Awf
> b. Malik? I said, yes. He ﷺ said, enter. So I said, shall
> I enter completely or partially? He ﷺ said, rather
> enter completely.
>
> Then he ﷺ said, O Awf b. Mālik count six before
> the Hour [i.e. signs before the Day of Judgement] the
> first [sign] of which is my death. So I started crying
> till he made me quiet. Then he ﷺ said, say one. So
> I said, one.
>
> [Then he ﷺ said], the second [sign] is the conquest
> of *Bayt ul-Maqdis*, say two. So I said, two.
>
> Then he ﷺ said, the third [sign] is death will occur
> frequently in my Ummah and they will get it like a
> plague occurs among goats, say three. So I said, three.

Next he ﷺ said, the fourth [sign] will be a fitnah in my Ummah. He ﷺ declared it to be a great Fitnah, then he said, say four. So I said, four.

After that he ﷺ said, the fifth [sign] is that you will have a lot of wealth to the extent that even if a person gives 100 Dinars to someone, he will be displeased at that too, say five. So I said, five.

Then he ﷺ said, the sixth [sign] will be a truce between you and *Bani Asfar*, then they will gather under 80 banners [and come to attack you]. Under each banner will be [an army of] 12,000. So on that day the camp of the Muslims will be in the land called *Al-Ghuta* in a city called Damascus.

Reported by Ṭabarānī[45] with a *Jayid Isnād*.

45. [TN] This *Ḥadīth* is *Saḥīḥ*. *Al-Muʾjam Al-Kabīr* vol.18, p.42 and *Musnad Aḥmad* vol.39, p.411. This is also reported in a summarised way in *Saḥīḥ Bukhārī Ḥadīth* no.3176 and *Sunan Ibn Mājah Ḥadīth* no.4042.

ḤADĪTH 19

وعن مكحول، عن معاذ بن جبل ﷺ قال: قال رسول الله ﷺ:
فسطاط المؤمنين بالغوطة، فيها مدينة يقال لها: دمشق، من خير
مدائن الشام.

Makhul, from Mūʾādh b. Jabal (ﷺ) he said the Messenger of Allāh
ﷺ said,

> The camp of the Muslims is at *Al-Ghuta* in a city
> called Damascus. It is among the best cities of *Shām*.

Reported by Abū ash-Shaykh b. Hayan[46]

46. [TN] This *Ḥadīth* is *Daʾif* because of the *Inqitaʾ* between Makhul and Mūʾādh
b. Jabal (ﷺ). *Tarīkh Dimishq* of Ibn ʾAsākir vol.1, p.229. However it becomes
Hasan Li Ghayrihi Inshā Allāh due to other *Mutaʾbaʾat* reports which have been
narrated by other companions that are *Saḥīḥ*. See *Ḥadīth* no.17 of this book
which is *Saḥīḥ*.

ḤADĪTH 20

وقال الإمام أحمد : [حدثنا أبو اليمان] ، ثنا أبو بكر-يعني ابن أبي مريم-
، عن عبد الرحمن بن جبير بن نفير، عن أبيه قال : حدثنا رجل من
أصحاب محمد ﷺ، أن رسول الله ﷺ قال : ستفتح عليكم الشام، فإذا
خيرتم المنازل فيها، فعليكم بمدينة يقال لها : دمشق، فإنها معقل
المسلمين من الملاحم، وفسطاطها منها بأرض يقال لها الغوطة.

Imām Aḥmad said, [Abul Yaman narrated to us][47], Abū Bakr narrated
to us meaning Ibn Abī Maryam, from Abdurahman b. Jubayr b.
Nufayr, from his father he said, a man from the companions of
Muḥammad ﷺ narrated to us that the Messenger of Allāh ﷺ said,

> Soon you will conquer *Shām*. So when you are given
> a choice to stay in a dwelling there then stick to
> [and go to] a city called Damascus because it will be
> the refuge of the Muslims in times of the *Malhamah*
> [great battle]. The camp of it will be at a land called
> *Al-Ghuta*.[48]

47. [TN] This is missing from the book however it has been corrected from
Musnad Aḥmad.

48. [TN] The *Isnād* is *Daʾīf*. This is because the narrator Abū Bakr b. Abī Maryam
has been criticised with elements of weakness. *Musnad Aḥmad* vol.29, p.13.
However it becomes *Hasan Li-Ghayrihi Inshā Allāh* due to other witnessing
reports which have been narrated by other companions that are *Saḥīḥ*. See
Ḥadīth no.17 of this book which is *Saḥīḥ*.

ḤADĪTH 21

<div dir="rtl">

وروى ابن مردويه، عن سماك، عن عكرمة، عن ابن عباس قال : رَبْوَةٍ
ذَاتِ قَرَارٍ وَمَعِينٍ. قال : أُنبِئتُ أنها أنهار دمشق .

</div>

Ibn Marduyah reports, from Samak, from Ikrimah from, Ibn ʾAbbās
(⁕) said [the meaning of the āyah], **"...a high ground having level
[areas] and flowing water"** [Sūrah Al-Muʾminun, āyah no.50]: I
have been told that it refers to the canals of Damascus.[49]

49. [TN] This *Isnād* is *Daʾīf. Tarīkh Dimishq* of Ibn ʾAsākir vol.1, p.204. However
there are other *Isnād* for this which are *Saḥīḥ.* See *Tafsīr Ibn Kathīr* vol.3, p.247,
Tafsīr At-Tabarī vol.18, p.26 and *Musanaf Ibn Abī Shaybah* no.32456.

CHAPTER TWO
What Has Been Mentioned Regarding the *Fitan* Arising From the East

ḤADĪTH 22

روى البخاري، ومسلم في صحيحهما -واللفظ لمسلم-، عن ابن عمر
رضي الله عنهما، أن رسول الله ﷺ قام عند باب حفصة، فقال: بيده نحو
المشرق: الفتنة هاهنا من حيث يطلع قرن الشيطان، -يعني المشرق-.

It has been reported from Bukhārī and Muslim in their *Ṣaḥīḥ* [books of *Aḥādīth*], and the words are of [*Ṣaḥīḥ*] Muslim, from Ibn ʾUmar (ﷺ) that the Messenger of Allāh ﷺ stood by the door (of the apartment of) Hafsah (ﷺ) and, pointing towards the East, he ﷺ said,

> The *Fitnah* would appear from this side, from where the horns of Shaytān would appear.[50]

Meaning the East.

50. [TN] *Saḥīḥ Bukhārī Ḥadīth* no.7093 and *Saḥīḥ Muslim Ḥadīth* no.2905 [6939].

ḤADĪTH 23

وعنه ﷺ، قال: سمعت رسول الله ﷺ يشير بيده نحو المشرق، ويقول: ها إن الفتنة هاهنا، ها إن الفتنة هاهنا -ثلاثاً-، حيث يطلع قرنا الشيطان، وفي لفظ آخر: ألا إن الفتنة هاهنا -مرتين-.

وفي بعض طرق البخاري، عن ابن عمر ﷺ قال: قام النبي ﷺ خطيباً، فأشار نحو مسكن عائشة، فقال: هنا الفتنة -ثلاثاً. من حيث يطلع قرن الشيطان.

وفي طريق أخرى: قام إلى جنب المنبر، وفي آخر: على المنبر.

In another *Ḥadīth* from him [Ibn ʾUmar] (ﷺ) he said, I heard the Messenger of Allāh ﷺ as saying while pointing his hands towards the east,

> The *Fitnah* would appear from this side, indeed the *Fitnah* would appear from this side, [He ﷺ repeated this] three times, from where the horns of Shayṭān would appear."[51]

In another wording,

> Lo, Fitnah would appear from this side...[52] [repeating it] twice.

In some routes [*Isnād*] of Bukhārī, from Ibn ʾUmar (ﷺ) he said, The Prophet ﷺ stood up to deliver a sermon, and pointing to ʾĀʾisha (ﷺ) dwelling (i.e. Eastwards), he ﷺ said,

51. [TN] *Ṣaḥīḥ Muslim Ḥadīth* no.2905 [6942].

52. [TN] *Ṣaḥīḥ Muslim Ḥadīth* no.2905 [6942].

Fitnah [will appear from] here, [repeating it] thrice, from where the horns of Shaytān would appear.[53]

In another route [*Isnād*] he ﷺ stood beside the pulpit[54], and in another stood on the pulpit.[55]

53. [TN] *Saḥīḥ Bukhārī Ḥadīth* no.3104.

54. [TN] *Saḥīḥ Bukhārī Ḥadīth* no.3511.

55. [TN] *Saḥīḥ Bukhārī Ḥadīth* no.7092.

ḤADĪTH 24

وعن ابن عمر ﷺ أيضاً، ذكر أن النبي ﷺ، قال: اللهم بارك لنا في
شامنا، اللهم بارك لنا في يمننا -قالها مراراً-، فلما كان في الثالثة، أو
الرابعة، قالوا: يا رسول الله، ففي عراقنا؟ قال: بها الزلازل، والفتن،
وبها يطلع قرن الشيطان .

Additionally from Ibn ʾUmar (ﷺ) that the Prophet ﷺ said,

> O Allāh! Bless for us our *Shām* and bless for us our
> Yemen.

He ﷺ said this many times, so when he said it for the third or fourth
time, they [the people] said, O Messenger of Allāh (ﷺ), then [also] in
our Iraq? He ﷺ said,

> There will be earthquakes and tribulations by
> means of it, and the horn of Shaytān will come out
> from there.

Reported by Bukhārī[56], Tirmidhī[57] and Ṭabarānī[58]. The words [in the
Ḥadīth] are from Ṭabarānī.

56. [TN] *Saḥīḥ Bukhārī Hadīth* no.1037.

57. [TN] *Sunan at-Tirmidhī Hadīth* no.3953.

58. [TN] *Muʾjam al-Kabīr of at-Ṭabarānī* vol.12, p.384.

ḤADĪTH 25

وروى مسلم عن فضيل، [عن أبيه] ، قال : سمعت سالم بن عبد الله
بن عمر يقول : يا أهل العراق، ما أسألكم عن الصغيرة، وأركبكم للكبيرة،
سمعت أبي عبد الله بن عمر يقول : سمعت رسول الله ﷺ يقول : إن
الفتنة تجيء من هاهنا،-وأومأ بيده نحو المشرق-، من حيث يطلع قرنا
الشيطان .

Muslim reported from Fudhayl [from his father] he said, I heard
Salīm b. ʾAbdullāh b. ʾUmar (﷽) saying,

> O people of Iraq how strange it is that you ask about
> the minor sins but commit major sins? I heard
> from my father ʾAbdullāh b. ʾUmar (﷽) saying
> that he heard the Messenger of Allāh ﷺ as saying
> while pointing his hand towards the east, "Indeed
> the Fitnah would come from this side, from where
> appear the horns of Shaytān."[59]

59. [TN] *Saḥīḥ Muslim Ḥadīth* no.2905 [6943].

ḤADĪTH 26

وروى الأعمش، عن عبد الله بن ضرار الأسدي، عن أبيه، عن عبد الله قال: قسم الله الخير، فجعل تسعة أعشاره في الشام، وبقيته في سائر الأرض، وقسم الله الشر فجعل جزءاً منه في الشام، وبقيته في سائر الأرض.

A'mash narrated from Abdullah b. Dhirar Asadi, he narrated from his father, he narrated from Abdullah b. Mas'ūd (ﷺ),

> When Allah distributed good, He placed nine parts [out of 10] of it in *Shām* and the remainder in the rest of the Earth. [When] He distributed bad, He placed one part [out of 10] of it in *Shām* and the remainder in the rest of the Earth.

It has been reported in the same way by Imām Aḥmad.[60]

60. [TN] This narration is not present in *Musnad Ahmad*. Rather there is a narration with a different *Sanad* and with a slightly different wording in *Musnad Ahmad* vol.9, p.458, and Allāh knows best. See *Al-Mu'jam Al-Kabīr* of Ṭabarānī vol.9, p.177 *Ḥadīth* no.8881 and it's *Isnād* is *Da'īf* due to the weakness of Abdullah b. Dhirar. Therefore this *Athar* is *Da'īf*.

ḤADĪTH 27

وعن زيد بن ثابت ﷺ قال: بينما نحن حول رسول الله ﷺ نؤلف
القرآن من الرقاع، إذ قال رسول الله ﷺ: طوبى للشام، قيل: ولم ذاك
يا رسول الله؟ قال: إن ملائكة الرحمن باسطة أجنحتها عليه.

Zayd b. Thābit (ﷺ) said, we were gathering the Qurʾan from scraps
of paper[61] whilst being gathered around the Messenger of Allāh ﷺ
when the Messenger of Allāh ﷺ said,

Tuba[62] [glad tidings] for *ash-Shām*[63].

It was said, O Messenger of Allāh, why is that for [?] He ﷺ said,

Indeed, the Angels of *Ar-Rahman* [The Most Gracious
Allāh] have spread their wings over it [*Shām*].[64]

61. [TN] There is a clear statement in this *Ḥadīth* that the Qurʾan was compiled
in the presence of the Messenger of Allāh ﷺ, as is proved by the wording in
this *Ḥadīth*. Similarly it was re-collected and re-compiled during the eras of
Abū Bakr and ʾUthmān (ﷺ).

62. [TN] Ibn ul-Athir said, *Tuba* here means, one who does good things. *An-
Nihiyah* vol.3, p.318. Al-Mubarakfuri said, i.e. comfort and a good life for it
and it's people. *Tuhfatul Ahwadhi* vol.10, p.315.

63. [TN] In a lot of the narrations the wording is, *Tuba* [glad tidings] for the
people of *Shām*. See *Takhrij Ahadith Fadha'il Ash-Shām Wa Dimishq* by Shaykh
Albānī p.9.

64. [TN] Mulla Ali Qārī said, meaning that the region of *Shām* and it's people
are protected from disbelief. *Mirqatul Mafatih Ḥadīth* no.6273. Al-Munawi
said, meaning that blessings descend here and dangers as well as harms are
warded off from it. *Faydul Qadir* vol.4, p.361.

It has been reported by Imām Aḥmad[65], Tirmidhī[66], Ṭabarānī[67] and it's *Sanad* is on the condition of *Saḥīḥ* [Bukhari].[68]

65. [TN] *Musnad Ahmad* vol.35, p.483, *Hadīth* no.21608.

66. [TN] *Tirmidhī Ḥadīth* no.3954.

67. [TN] *Al-Muʾjam Al-Kabīr* vol.5,p.158.

68. [TN] See *Saḥīḥ At-Targhīb At-Tarhīb Ḥadīth* no.3095, *Silsilah As-Sahīhah* of Albānī *Hadīth* no.503.

ḤADĪTH 28

وعن سالم بن عبد الله، عن أبيه قال : قال رسول الله ﷺ : ستخرج نار
من حضر موت، -أو من بحر حضر موت- قبل يوم القيامة، تحشر
الناس، قال : قلنا يا رسول الله فما تأمرنا؟ قال : عليكم بالشام.

Salim b. Abdullah narrates from his father [Abdullah b. Umar (؅)] that the Messenger of Allāh ﷺ said,

> Soon, before the Day of Judgement, a fire shall emerge at Hadramawt or from the sea of Hadramawt which shall gather the people.

We said, O Messenger of Allāh (؅), what do you command us to do? He ﷺ said,

> Stick to [and go to] *Shām*.

It has been narrated by Imam Ahmad[69] and Tirmidhī[70]. (Tirmidhī) has said that this *Hadīth* is *Hasan Sahīh Gharīb*.

69. [TN] *Musnad Ahmad* vol.9, p.276, *Hadīth* no.5376, vol.8. p.134, *Hadīth* no.4536. *Sahīh ul-Jami'* *Hadīth* no.3609

70. [TN] *Tirmidhī Hadīth* no.2217. See *Sahīh Targhīb Wat-Tarhīb Hadīth* no.3096

ḤADĪTH 29

وعن أبي إدريس الخولاني، عن عبد الله بن حوالة ﷺ قال: قال
رسول الله ﷺ: إنكم ستجندون أجناداً، جنداً بالشام، وجنداً
بالعراق، وجنداً باليمن، فقال ابن حوالة: خر لي يا رسول الله؟ قال:
عليك بالشام، فمن أبى فليلحق بيمنه، وليسق من غدره، فإن الله
تكفل لي بالشام وأهله.

From Abū Idris Khawlani (Tabi'i), from Abdullah b. Hawalah (ﷺ), he
said that the Messenger of Allāh ﷺ said,

> [In the future] You will discover groups of armies,
> an army in *Shām*, an army in Yemen and an army
> in Iraq.

Ibn Hawalah said, Choose for me O Messenger of Allāh ﷺ [in case I
encounter that and reach that period]. He ﷺ replied,

> Stick to [and go to] *Shām*, [but] whosoever is unwilling
> [and refuses to go to *Shām* then] go to Yemen, and
> drink from its water [ponds]. This is because indeed
> Allah has guaranteed [and assured] to take special
> care of *Shām* and it's people for me.[71]

So when Abu Idris Khawlani would narrate this *Ḥadīth* he would
turn his attention to Abu Amir and he would say,

71. [TN] This *Ḥadīth* is *Saḥīḥ*. *Saḥīḥ ul-Jami' Ḥadīth* no.3659, *Saḥīḥ Ibn Hibban
Ḥadīth* no.7306, *Mustadrak al-Hakim* vol.4, p.510 and *Musnad Ahmad* vol.33, p.466.
In this *Ḥadīth* the words "stick to [and go to] *Shām*" have been mentioned once.
While in *Musnad Ahmad*, the words "stick to [and go to] *Shām*" have appeared
3 times. This means that the emphasis has been placed on holding onto [and
going to] *Shām*. Before the Day of Judgement, the descent of Isa (ﷺ) will be in
this area, for this reason, migration to this area has also been necessitated,
and whosoever cannot migrate to the area of *Shām*, he should make a journey
towards Yemen.

Whoever has Allāh as his guarantor will not be wasted [or suffer loss].

Hafiḍh Abū ʾAbdullāh Al-Maqdisi said, this *Ḥadīth* is well known and its chain is a *Ṣaḥīḥ Isnād*. Without a doubt, it has been narrated by many people from Abdullah b. Hawalah (ﷺ).

ḤADĪTH 30

وعن بهز بن حكيم، عن أبيه، عن جده قال : قلت يا رسول الله ﷺ :
أين تأمرني؟ قال : هاهنا، ونحا بيده نحو الشام.

Bahz b. Hakim, from his father, from his grandfather, he said,

I said, O Messenger of Allāh ﷺ where do you order
me [to go]? He ﷺ said, There [i.e. this way], and he ﷺ
pointed towards *Shām* with his hand.[72]

It was narrated by Imam Ahmad[73], Nasā'ī[74] and Tirmidhī[75]. He
(Tirmidhī) said that this *Ḥadīth* is *Hasan Saḥīḥ*.

72. [TN] This *Ḥadīth* is *Saḥīḥ*. See *Takhrīj Ahadith Fadhāil Ash-Shām Wa Dimishq*
by Shaykh Albānī p.36

73. [TN] *Musnad Ahmad* vol.3, p.233, *Ḥadīth* no.20031

74. [TN] This narration is not present in *Sunan Nasā'ī Kubra* or *Mujtaba*, and
Allah knows best.

75. [TN] *Sunan Tirmidhī Ḥadīth* no.2192

ḤADĪTH 31

وعن بكار بن تميم، عن مكحول، عن واثلة ﷺ قال : سمعت رسول الله ﷺ يقول لحذيفة بن اليمان، ومعاذ بن جبل -وهما يستشيرانه في المنزل-، فأومأ إلى الشام، ثم سأله، فأومأ إلى الشام، قال : عليكم بالشام، فإنها صفوة بلاد الله عز وجل، يسكنها خيرته من خلقه، فمن أبى فليلحق بيمنه، وليسق من غدره، فإن الله عز وجل تكفل لي بالشام وأهله.

From Bakar b. Tamim. from Makhul, from Wathila ﷺ, he said, I heard the Messenger of Allāh ﷺ saying to Hudhaifah b. Yaman and Mu'adh b. Jabal (ﷺ), and they were both consulting him about somewhere to live, so he ﷺ pointed to *Shām*. They asked him ﷺ again, so he pointed to *Shām* and said,

> Stick to [and go to] *Shām*, for it is indeed the chosen land of Allāh the Mighty and Majestic. It is inhabited by the best of Allāh's creatures. [However] whosoever is unwilling [and refuses to go to *Shām* then] go to Yemen, and drink from its water [ponds]. This is because indeed Allāh has guaranteed [and assured] to take special care of *Shām* and it's people for me.

It has been narrated by Hafiḍh Yahya b. Sa'id from his *Isnād*.[76]

76. [TN] *Al-Mu'jam Al-Kabīr* by Ṭabarānī vol.22, p.58, *Ḥadīth* no.137. This *Isnād* is *Da'īf* for 2 reasons, 1. Bishr b.Awn and Bakar b. Tamim are Majhul, see *Mizan ul-I'tidal* vol.1, p.340 and 2. Al-Walīd b. Hamad Ar-Ramli is *Da'īf*, see Al-Irshad By Khalili vol.1, p.409. Although this *Ḥadīth* is not Sahih from Wathilah (Radī Allāhū 'Anhu) the wording of the *Ḥadīth* is similar to other *Saḥīḥ Shawahid* narrations. See *Saḥīḥ ul-Jami' Ḥadīth* no.3949.

ḤADĪTH 32

وعن فضيل بن غزوان، [عن أبيه قال: سمعت سالم بن] عبد الله بن
عمر ﷺ يقول: يا أهل العراق، ما أسألكم عن الصغيرة، وأركبكم
للكبيرة، سمعت أبي عبد الله بن عمر يقول: سمعت رسول الله ﷺ
يقول: إن الفتنة تجيء من هاهنا، -وأومأ بيده نحو المشرق.- من حيث
يطلع قرنا الشيطان، وأنتم يضرب بعضكم رقاب بعض، وإنما قتل
موسى الذي قتل من آل فرعون خطأ، فقال الله عز وجل له: وَقَتَلْتَ
نَفْسًا فَنَجَّيْنَاكَ مِنَ الْغَمِّ وَفَتَنَّاكَ فُتُونًا فَكَذَّبُوهُمَا .

From Fudhayl b. Ghazwan he said, I heard ʾAbdullāh b. ʾUmar (ﷺ)
saying,

> O people of Iraq how strange it is that you ask about
> the minor sins but commit major sins? I heard from
> my father ʾAbdullāh b. ʾUmar (ﷺ) saying that he
> heard the Messenger of Allāh ﷺ as saying while
> pointing his hand towards the east,

> "Indeed the Fitnah would come from this side,
> from where appear the horns of Shaytān and you
> would strike the necks of one another; and Mūsā
> (ʾAlayhisalām) killed a person from among the
> people of Pharaoh unintentionally and Allāh, the
> Exalted and Glorious, said, '...**And you killed
> someone, but We saved you from retaliation and
> tried you with a [severe] trial....**'"[77] [Sūrah Ṭahā,
> āyah no.40]

Reported by Bukhārī[78] from this Ḥadīth which is Marfūʾ to the
Prophet ﷺ.

77. [TN] Saḥīḥ Muslim Ḥadīth no.2905 [6943].

78. [TN] Saḥīḥ Bukhārī Ḥadīth no.7092.

Concluding [with] all complete praise is due to Allāh alone, and may peace and blessings be upon Sayidina Muḥammad, his family and companions [as well as those who follow him].

APPENDIX
Additional *Ahadīth*
Related to *Shām*

ḤADĪTH 1

Abū Dhar (﷽) said,

> I said "O Messenger of Allāh ﷺ which Masjid was
> first built on the surface of the Earth?" He ﷺ said,
> "Al-Masjid ul-Ḥarām [in Makkah]." I said, "Which
> was built next?" So he ﷺ replied, "Al-Masjid ul-
> Aqsa⁷⁹ [in Jerusalem]." I said "What was the period
> of construction between the two?" He ﷺsaid, "40
> years." Then [He ﷺ said], "Wherever [you may be,
> and] the time for *Ṣalāh* becomes due, perform the
> *Ṣalāh* there, for the best thing is to do so." [i.e. to
> offer the *Ṣalāh* on time].⁸⁰

79. [TN] The name al-Masjid ul-Aqsa was historically applied to the entire
sanctuary and the buildings in it, [one of] the most important of which is the
Dome of the Rock which was built by 'Abdul Malik b. Marwan in 72 *Ḥijrī* which
is regarded as one of the greatest Islamic historical buildings. However today
the name is applied to the great Masjid which is situated in the southern part
of the sanctuary plateau [and not the Dome of the Rock]. See *Al-Mawsu'ah Al-
Philiastiniyah,* vol.4, p.203

Praying *Ṣalāh* in Masjid ul-Aqsa is 250 times greater in reward than in
other Masājid except for the Ḥarām in Makkah and the Prophet ﷺ Masjid in
Madinah. See *Mustadrak Al-Ḥākim* vol.4, p.509 and this *Ḥadīth* is *Ṣaḥīḥ.*

80. [TN] *Ṣaḥīḥ Bukhārī Ḥadīth* no.3366.

ḤADĪTH 2

Ibn ʾUmar (﷦) relates that a freed slave of his approached him and said, times have become difficult on me and I want to go to Iraq. He said, why not [go to] *Shām* the land of resurrection. Have patience foolish[81] lady for indeed I heard the Messenger of Allāh ﷺ saying,

> Whoever has patience during the difficulties of Madinah then I will be a witness or intercessor for him on the Day of Judgement.[82]

81. [TN] Referring to the young person who does not follow the words of others.

82. [TN] This *Ḥadīth* is *Saḥīḥ*. *Saḥīḥ Muslim Ḥadīth* no.1377 and *Sunan At-Tirmidhī Ḥadīth* no.3918. The meaning of times being difficult is that there was a drought. There is a clear indication of the virtue of living in Madinah and being patient with its hardships.

ḤADĪTH 3

ʾAbdullāh b. ʾAmr (🙏) said, Allāh's Messenger 🙏 said,

> Indeed when Sulaymān b. Dāwūd (🙏) [re-]constructed *Bayt ul-Maqdis* he asked Allāh for three things. He asked Allāh for judgement concurring with His judgement, so Allāh granted him that.
>
> Then he asked Allāh for sovereignty that would not belong to anyone after him and He granted him that.
>
> He asked Allāh that if any man went out of his house only wanting to pray in this Masjid [Masjid ul-Aqsa], that he would emerge free of sin as on the day of his mother bore him. We hope that Allāh, may He be Glorified and Exalted, has granted that to him.[83]

83. [TN] This *Ḥadīth* is *Saḥīḥ*. *Saḥīḥ ul-Jami Ḥadīth* no.2090 and *Musnad Aḥmad* vol.11, p.220.

ḤADĪTH 4

Abū Hurayrah (�radyAllahu) said, Allāh's Messenger ﷺ said,

> There shall not cease being a group in my Ummah maintaining the command of Allāh, they shall not be harmed by those who oppose them, fighting their enemies. Whenever one war goes away, a war breaks out with another people. Allāh diverges the hearts of a people to provide sustenance for them [the group in the Ummah] from it, until the Hour comes to them, as if it is a piece of the dark night. So they will be alarmed by that, such that they constantly wear armour for that.

Additionally, Allāh's Messenger ﷺ said,

> They are the people of *Shām*.

Allāh's Messenger ﷺ scraped the ground with his finger, indicating the direction of *Shām* until he hurt it.[84]

84. [TN] This *Hadith* is *Sahih. Silsilah Sahīhah Hadith* no.3425. Shaykh ul-Islām Ibn Taymiyyah said, the Prophet ﷺ highlighted the distinct character of the people of *Shām* by noting that they will continue to comply with the commands of Allāh until the end of time, and that the victorious group will remain among them until the end of time. This is speaking of an ongoing matter that will remain with them, that they will be numerous and strong. This description does not apply to anyone in the Muslim world except the people of *Shām*... knowledge and *Īmān* are still present in that land, and whoever fights in that land to support the *Īmān* will be victorious and will be granted divine help. *Majmū ul-Fatāwā* vol.4, p.449.

ḤADĪTH 5

The Prophet ﷺ said,

> I have been warning you about the *Dajjāl* who has
> one abraded eye. [The narrators] said, I think he
> said the left eye.[85] He will have with him mountains
> of bread and rivers of water, and his sign will stay in
> the earth for forty mornings, and his authority will
> reach everywhere. He will not come to four Masājid:
> the Ka'bah [in Makkah], the Masjid of the Prophet
> [in Madinah], al-Masjid ul-Aqsa [in Jerusalem] and
> the Masjid of Tur [in Sinai].[86]

85. [TN] From other *Ḥadīth* it is evident that both of *Dajjāl's* eyes will be
defective.

86. [TN] This *Ḥadīth* is *Saḥīḥ. Musnad Ahmad Ḥadīth* no.23139. Abū Bakr (ؓ)
said, The Messenger of Allāh ﷺ told us, "The *Dajjāl* will emerge from a land
in the east called *Khorasan.*" This *Ḥadīth* is *Saḥīḥ*, see *Sunan Tirmidhī Hadith*
no.2237.

ḤADĪTH 6

Mūʾādh b. Jabal (🙠) said, Allah's Messenger 🙠 said,

> *Bayt ul-Maqdis* will flourish when Yathrib is in ruins, and Yathrib will be in ruins when *Malhamah* [great battle] appears. The *Malhamah* appears with the conquest of Constantinople and Constantinople will be conquered when the *Dajjāl* appears.[87]

87. [TN] This *Ḥadīth* is *Saḥīḥ*. *Saḥīḥ ul-Jami Ḥadīth* no.4096 and *Sunan Abū Dāwūd Ḥadīth* no.4294 .

ḤADĪTH 7

Irbad b. Sariyah (⬡) said, Allah's Messenger ⬡ said,

> O Ibn Hawalah when you see that the Caliphate has settled in the blessed land [Jerusalem] then earthquakes and abounding grief are close as well as tremendous affairs and [then] on that day the Hour [Day of Judgment] is closer to the people than this hand is to your head.[88]

88. [TN] This *Ḥadīth* is *Saḥīḥ*. *Saḥīḥ ul-Jami'* *Ḥadīth* no.7838 and *Sunan Abū Dawud* *Ḥadīth* no.2535

ḤADĪTH 8

Aws b. Aws Ath-Thaqafī (⌘) that he heard the Messenger of Allāh ⌘ saying,

> Isa b. Maryam (⌘) will descend at the white minaret east of Damascus.[89]

89. [TN] This *Ḥadīth* is *Saḥīḥ*. *Al-Muʾjam Al-Kabīr Ṭabarānī Ḥadīth* no.590. *Saḥīḥ Al-Jami As-Saghīr Ḥadīth* no.8169. *Takhrīj Ahadith Fadhāil Ash-Shām Wa Dimishq* by Shaykh Albānī p.61

ḤADĪTH 9

Nawas b. Sam'an (☙) said that Allāh's Messenger ☙ made a mention of the Dajjāl one day in the morning... [then he ☙ said],

> The son of Maryam will kill the *Dajjāl* at the gates of *Lud*...[90]

90. [TN] *Saḥīḥ Muslim Ḥadīth* no.2937 *Lud* is a place in Palestine which is near Jerusalem.

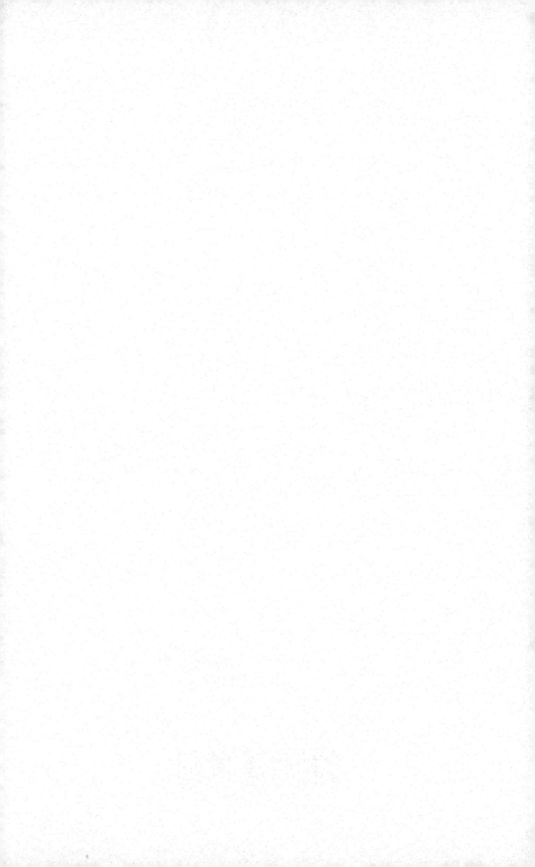

Printed in Great Britain
by Amazon

42277833R00046